T0124901

# Petites Luxures

INTIMATE STORIES

# Petites Luxures

## INTIMATE STORIES

LANNOO

# FOREWORD

It is almost two years now since I asked you to tell me stories from the fragments of your intimate lives, and several hundreds of you wrote back from all over the world to send me your memories of past mischief and adventure.

Though we were only able to select fifty of your stories for this publication, these sketches all testify to the infinite range of possibilities that exist for men and women in the matters of love and sexuality (alone, or enjoyed within a couple or a threesome, a foursome or a moresome, in a room, at the heart of nature, or at the office), but always with one thing shared in common, namely pleasure.

Some of these stories will make you smile, while others will will undoubtedly take you back to adventures of your own, but whatever happens, just let your imagination stroll and wander down the naughty pathways of desire...

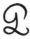

# TAMARA

This is the story of two girls.

Both a little shy, but also curious – and poetic. Having spent the day together, they find themselves back in the apartment of one of the girls, with a bottle of wine and some of their favourite books of poetry to share. They take it in turns to read out poems, and then, after a few glasses of wine, they initiate a game: writing the most beautiful verses onto each other's skin.

This begins, of course, with the hands, and then the arms, the back, and so on and so forth, descending ever lower and lower... Tenderly, they exchange their clothes for lines of poetry and naked skin. They then set out to read these lines, first without even touching, and then by tracing with the fingers, and finally with the tongue.

The most beautiful line of all begins at the knee of one of the girls, and ends at the break of day.

*Tamara*
*Budapest, Hungary*

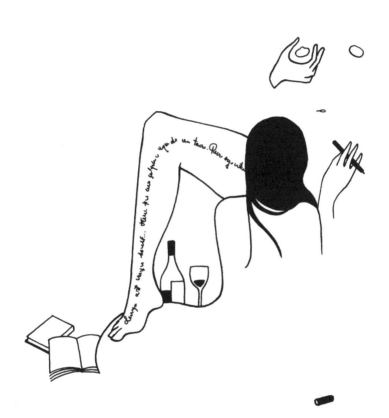

# VICTOR

I was with a girl I had met just a few days before, and we were out walking in the forest, picking mushrooms. I really liked her one hell of a lot. At first, we just went off and did our own thing, but we gradually got drawn closer together. We started out talking in platitudes and ended up lying back on a bed of moss, caressing each other in the middle of the woods.

I have never been so excited in my life, torn between desire and the terrible fear that, given the noise we were making, anyone out for a stroll might catch us in the act at any moment.

*Victor*
*Grenoble, France*

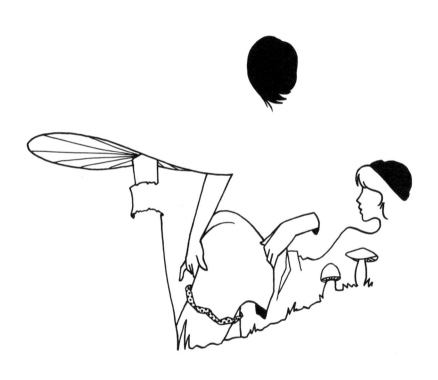

# MARIANNA

Coming back from a bar late at night, my boyfriend and I were far too turned on to wait until we got home. What should have been a fifteen-minute walk took nearly an hour – we stopped to make love in an alley (spied on by a taxi!), on the bonnet of a car, and by the time I reached my front door, I was entirely naked, strutting my way down the street ahead of him.

The following morning, I retraced my steps to recover my knickers – left hanging on the windscreen wiper of the car – but someone had already removed them... Oops! That boyfriend has since sadly passed away, but it's still one of my favourite sexy memories

*Marianna*
*London, England*

# CALAME

My wife was breastfeeding our daughter and, engorged with milk as they were, her breasts were a hub of sensuality that just fascinated me. During one of our episodes of passionate jousting, my Amazonian lover was riding on top of me while I caressed her chest adoringly. I never tired of playing with her trembling breasts, and their highly erectile nipples...

As our pleasures merged together, my hands took an ever firmer grip on those two orbs. The vibrant nipples, the throbbing vessels... Our orgasms and our fluids were surging up together: as my semen flooded her deep inside, her milk came cascading all over my face.

*Vive la diversification!*

*Calame*
*Embrun, France*

12

# MORGANE

Having met her that same afternoon, I invited her back to my place. She had blown my mind in a way I couldn't really understand...

In the evening, when she stood behind me and took me in her arms, I was suddenly overwhelmed by a great tenderness!

I had lit some candles on a dresser that had been covered by a scarf. Sat on the sofa, she settled on top of me. Face to face, without saying a word, we looked at each other for the longest time, until, at last, I accepted her kiss.

By the time I opened my eyes, the scarf on the furniture had caught fire, and huge flames were devouring the wall! She stood up, took off her T-shirt and beat the flames to smother the fire! Topless, she took me against the wall. It was the most beautiful night of my life. It's eight years now since she died, but every wall within my body is still aflame with her.

*Morgane*
*Nantes, France*

# THOMAS

That night my device projected stars onto the ceiling, and onto your skin.

That night, beneath those stars, I made love with you as if you were the principal star in orbit around my head.

That night, I marked your body as much as you tortured my soul.

That night, I kissed the moon-shaped tattoo that adorns your hip so beautifully.

That night, I realised that I loved you more than astronomy.

*Thomas*
*Senlis, France*

# MARIANNE

It was my first time with this man that I would go on to fall madly in love with. We found ourselves in a guest room in the heart of the Cévennes. While I was admiring the view through a little bull's-eye window, he knelt down behind me, lifted my skirt, slid his tongue between my cheeks and proceeded to probe me to an orgasm.

On the one hand I was experiencing something extraordinarily intimate, and on the other I had an expanse of nature stretching out in front of me as far as the eye could see. It's a combination I'll never forget.

*Marianne*
*Aubenas, France*

# CHLOÉ

One day my partner grabbed hold of me, lifted me up and sat me down, face-on, astride his broad shoulders, where he proceeded to lick me, at a height six feet up from the ground!

*Chloé*
*Guadeloupe*

# STAN

Seven-thirty in the evening, with the autumn sun in its descent.
We were barely back through the front door and already she was
down on her knees in front of me.
And it still gets to me, even now, when I recall
Her head moving back and forth in silhouette.

*Stan*
*Paris, France*

# FRANÇOIS

We meet up in the Ardennes, after a month of separation, far away from where we live in Brittany. Taking a morning stroll in the heart of nature, we stop at a belvedere to admire the misty landscape from the cliff... Wrapped up tight in our winter clothes, desire overwhelms us. Her, leaning back against the railing overlooking a ravine. Me behind her, with my trousers around my ankles, my hands all over her hips and arse. Kisses on the neck, caresses, and thrusting from the hip.
We watch, with some satisfaction, as my sperm takes the great leap forward!

*François*
*Brest, France*

# ATHENA

My boyfriend and I are currently in a long-distance relationship, and as a way to share our orgasms with each other, we act out our fantasies together on Skype. Since his mother tongue is French, I try to learn sexy vocabulary and naughty little expressions in French just to please him. So, for example, I'll cry out: "*Ah oui! Oui! Oui!*", "*Plus fort, s'il te plaît*", or "*Jouis bébé, jouis pour moi!...*" 'Oh, yes! Yes! Yes!', 'Harder, please!', 'Come for me, baby, come for me'... Just a few simple words that always seem to do the trick.

He generally sits in front of his computer and lays a hand out on his chair, imagining that I'm sat on top of him and we're holding hands, our fingers intertwined. We constantly invent new settings and scenarios so we can share as much pleasure together as possible.

*Athena*
*Saint Petersburg, Russia & Chengdu, China*

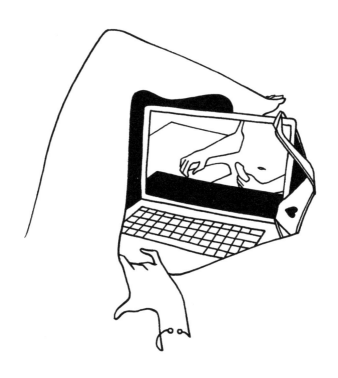

# MALVIKA

She cornered me over by the swimming-pool steps and her fingers slipped inside the bottom of my swimsuit. One finger gently caressed me, while the other ventured forth inside my pussy. She played with me, teasing me, until I came very hard in he swimming pool, with her other hand covering my mouth to silence my cries of pleasure.

*Malvika*
*Delhi, India*

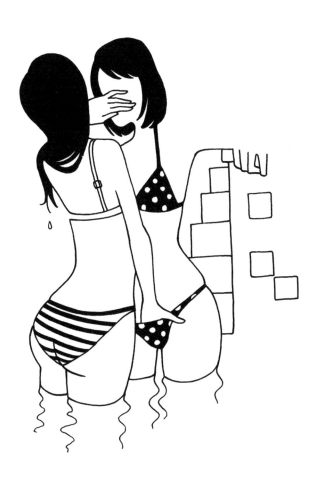

# LISA

I often go into my friend's bathroom to do my makeup while he's taking a shower. It's a simple shower with a curtain. In front of the curtain, there's a sink with a mirror. So I stand with my back to the shower, but in the mirror I get a little glimpse of a slight opening in the curtain.

One morning, as I was getting ready, to my great surprise, I could see my friend's cock – and nothing but – sticking out through the half-open curtain.

Without a second's hesitation, I threw myself onto it, finished him off and left as if nothing had happened.

*Lisa*
*Saint-Étienne, France*

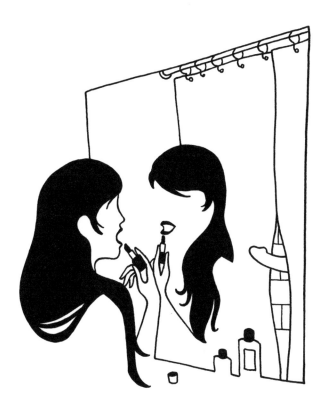

# JESSY

Madame is in the kitchen, preparing a fine meal, and I go off to meet our guest at the station. A wine-tasting session with a nice drop of Jurançon, followed by captivating conversation, and now here we are, exchanging massages, caresses and kisses. The moaning blooms, the clothing slips away, and our breath becomes one. Mademoiselle, with her long brown curly locks, is stretched out to my left, and Madame with her wavy chestnut hair lies to my right. I am witness to their first languorous kiss, which takes place just above my face as they caress each other's breasts and reach for my cock.

A case of perfect osmosis, and a night full of memories.

*Jessy*
*Paris, France*

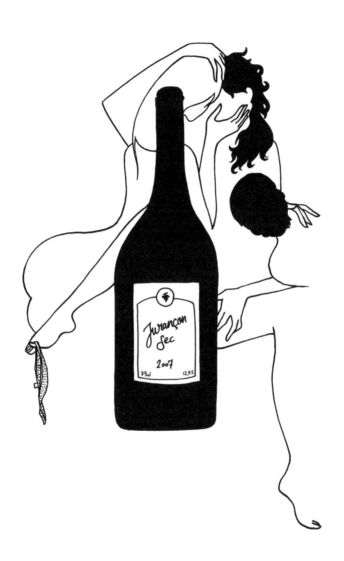

# MORGANE

Last winter, in Paris.

After an evening with friends, and warmed by alcohol, we board a train on the RER A line. Between Étoile and La Défense, we are subsumed by desire. Without pausing to think, he unzips his fly and sets me down astride him while trying to get into my skirt (we're in luck, I'm wearing stockings). Minutes pass in great intensity, which eventually builds until finally, we orgasm together. Grande Arche, the end of the line. And there's nothing left to show for our antics, but two very satisfied looking faces and my febrile legs, down which his hot cum is now starting to trickle its winding way... *Mind the gap!*

*Morgane*
*Paris, France*

# JULIEN-BRICE

Sudden desire.
We arrive in the underground car park.
We park up front-end forward, shielded from the cameras and away from prying eyes.
With the bonnet still hot, we shed our clothes in a trice. At Speed – with a capital 'S'.
Trousers around our knees, we really couldn't care less.
Without even checking the levels, we go straight to penetration, doggy style on the hood.
Little cries and groans. With fear and stress to suppress the noise.
But with the two of us about to come, the increased resonance of pleasure.
And then, without restraint,
discretion totally out of the window, the echoing sound of joy.
Ejaculation, and smiles across our lips.
Mischief accomplished.
We get dressed.
The two of us very happy in the public darkness.
Hand in hand, the exchange of a languorous kiss.
Then off to the cinema, for the second half...

*Julien-Brice*
*Reims, France*

# EMMA

We were kissing, and I was lying on top of her. Just as I was taking off my T-shirt, my head got stuck in the neckline, and then my arms. In the rush, I banged my head against the wall in front of me. The shock made me recoil and I fell to the ground... Knowing that there was a space of forty centimetres between the bed and the wall, I found myself bent over backwards, folded in four and stuck, in a fairly original position, with my head still trapped inside my T-shirt.

*Emma*
*Colmar, France*

# GWEN

The virtual exchanges had been sultry and suggestive. A sensual invitation to discover each other... And then a first meeting, the scene is set: waiting for an unknown stranger in a hotel room, the door left slightly ajar...

A feverish, trembling waiting, standing, as agreed, with a blindfold over my eyes... He knocks; he enters. I sense his movements behind my back, then his hands on my hips, raising my dress up over my arse, gently lowering the lace... his fingers becoming adventurous now, taking, possessing... He directs me to the bed, and gets me to go down on my knees, in just my stockings and stilettos... long games of fingers and tongues. Ecstasy mixed with the stress of the whole scenario, until, finally, he removes the blindfold...

The birth of a great erotic friendship.

*Gwen*
*Rennes, France*

# KELLY

Back when I was still in college, my boyfriend and I were taking advantage of having his parents' house to ourselves for New Year, and we did it just about everywhere, from the bedroom to the living room.

His family still hadn't taken down the Christmas tree, and I was holding on to it to keep from sliding on the floor. When I reached my orgasm, I brought the tree crashing down on top of us. We couldn't stop laughing.

This episode remains one of my loveliest memories of our time together.

*Kelly*
*Long Beach Island, United States*

# ROSE

I was his final appointment of the day. Lying back on his table, the longer the conversation went on, the more eroticised the subtext.

I could have stayed under his needle for hours, just to keep the discussion going. Tattoo finished, I stood up. He kissed me; we kissed. I went down, he turned me over. An hour of flirting since the start of the session, and then he took me there and then, on the tattoo parlour table.

*Rose*
*Paris, France*

# CHIARA

I was in bed with my boyfriend, iPhone in hand.

He wanted to try something new, so he grabbed a virtual reality headset and connected his phone to it. A second later I realised that I was watching a porn film shot from the first-person perspective, in 360 degrees.

While I was watching the film, he slid his face between my thighs.

I remember I was horny as fuck; it felt like I was cheating on him, without actually doing the cheating. So was it real, or was it virtual?

*Chiara*
*Milan, Italy*

# ÉMILIE

We're in the elevator; him in a three-piece suit and me in a dress. Going back to his place; twenty floors up. The door closes on the ground floor. He puts his back against the glass and undoes his trousers. I go down on my knees and give him a blow job. It was great fun and a real thrill – with the added terror thrown in for good measure, that someone might easily have called for the lift.

*Émilie*
*Paris, France*

# BELLA

My boyfriend and I had gone away camping in a very small town, and one evening we decided to go to the cinema. There was nobody else in the theatre and we were alone in the empty seats. My boyfriend started to become very tactile, and it was really turning me on. I was wearing a skirt, so I lifted it up and he started to finger me, and one thing led to another... He took off his trousers and I straddled him in his seat.

I remember being able to make as much noise as I wanted, since the soundtrack of the film was totally drowning out my screams of pleasure.

He started to take me from behind and I remember sending my popcorn flying in all directions.

*Bella*
*Calgary, Canada*

# ELENA

Once upon a time, I had rather a lot to drink. I was so drunk that I wanted to dance and do crazy stuff, but it was late – about six in the morning – and my boyfriend decided to take me home. Apparently – because I don't remember a thing – I really didn't want the night to end. Then suddenly, while he was driving, I got completely naked and started playing with myself. In a moving car. In the passenger seat.

We stopped at a red light, and there was a huge bus next to us full of elderly tourists, who were shocked by the sexy show.

I woke up at eleven the next morning with a hangover, still naked, but in the back seat with my boyfriend. That was the last time that I had a drink!

*Elena*
*Malaga, Spain*

# ALEXIA

August 18, 01:00 am. Opposite the lighthouse at the Estacade de Capbreton.

The ocean restless, as we take a night stroll on the pier after a few glasses of wine. I am out walking with my old love and we head straight toward the end of the pier, where there is nothing and no one to see. Just the light of the old semaphore, a few metres away. I go down on my knees as he stands there facing the lighthouse, facing the waves, face to face with infinity. I really love having him in my mouth. I'm getting wetter and wetter, as I am soaked by the waves on all sides. I'm excited by the saltiness of our skins.

I watch him looking out at this infinity spread before him. The lighthouse is throwing just enough pale light on me for him to see my lips enclosed around him. I sense an animal tension growing, in one of the most romantic settings imaginable.

Facing out across the sea, he thinks he's in charge of the boat, but in truth, he knows it's me who is the captain. I lick his salty cock, my hand holding him tight and never once taking my eyes off him.

Under this starry Atlantic sky, looking out toward the horizon, he comes all over my lips.

*Alexia*
*Paris, France*

# LUCAS

The first time I found myself in bed with her, the pleasure just kept on mounting and her whole body ended up being carried away on the wave of a huge orgasm. I asked her if everything was okay and she answered: "Yes, you make me tremble."
In a bed, it doesn't pose so many problems, but on the edge of her sink with all those products in the way, there's a lot more chance of breakages all round.

*Lucas*
*Bordeaux, France*

# MARY

When we first started seeing each other, we were over at his apartment with all our friends. We crossed paths on the stairs, and he just lifted up my skirt and entered me there on the spot. Against the wall, halfway up the stairs, with my foot on the railing and his hand against my mouth. The living room door wasn't even closed – but they never knew a thing.

*Mary*
*London, England*

# GIGI

I left the classroom.
She caught up with me in the corridor, and smiled.
I took her hand with its strong, thin fingers.
"You look good",
she whispered.
I pulled her through a door
away from the hectic college crowd.
We stumbled up a staircase.
"Where are we going?"
She laughed.
All the way up.
I sighed.
The stairs came to an end.
"Roof Access" announced the door.
We were out of breath.
I pushed her up against the wall.
Her hands became entangled in my long brown hair.
Her short fuzzy curls were tickling against my breasts
I kissed her caramel skin,
lower and lower;
my tongue slipped inside.
The stairwell echoed back at us.
Later, we laughed, when we noticed
the letters in red on the door proclaiming:
DANGER!

*Gigi, Madison, United States*

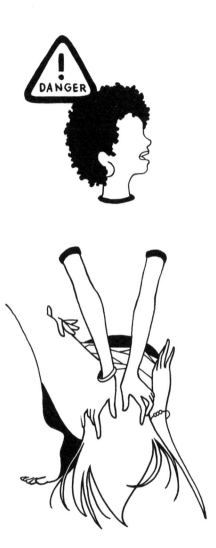

# BIANCA

My boyfriend and I went on an incredible camping trip in the
Cederberg Mountains of South Africa. We had heard rumours
of a magnificent pool at the bottom of the valley, and decided
to set off on an adventure in the sweltering heat to find it. Along
the way, I spotted the entrance to a small cave that was hidden
behind a waterfall. Guided by curiosity, we ventured inside.
There was just enough room to sit down, with a rocky ledge that
sloped down to a freshwater pool. The walls were covered in
damp moss and frogs were croaking in the nooks of the alcove.
I stripped off to cool myself down and plunged into the water.
My lover was sat on the ledge, staring out into the valley, listening
to the sound of the water falling all around. Everything was just
so perfect; I couldn't help myself. I started to kiss my way up his
legs, my mouth and hands dripping wet.
I worshipped him on my knees in the water, as I took him in
my mouth. He was completely in a trance, and would later tell
me that it felt as if he was in a dream, with this nymph emerging
from the water. It was the most memorable blowjob in the
world. I was so turned on that we made love in the cave, pressed
up against the stone, drenched by the water falling all around us.

*Bianca*
*Cape Town, South Africa*

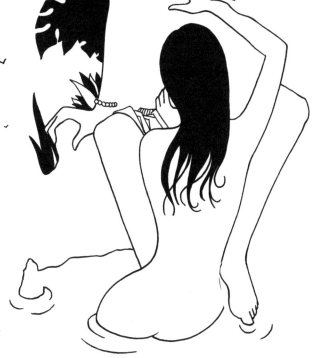

# MAHIÉDDINE

It was the first time together for me and my last girlfriend. We were gently warming each other up, and everything was perfectly normal, until the point when I had to put on a condom. I was paralysed; I so badly wanted to make it magical that I completely forgot how to do it. So I took it, unrolled it in my fingers and blew into it like a balloon. It was then that she sat on the bed, took a look at me and said: "What the Hell are you doing?" Then we laughed like mad to the point of tears, which was followed by the most amazing night of my life.

*Mahiéddine*
*Buhl, France*

# MALISA

We're sitting in front of the piano in the basement of this school, with him looking on and me just quietly tickling the ivories. He gets up, gives me a signal to carry on playing, and comes a little closer. He lifts me up by the waist and pulls back my chair. I carry on playing. He turns me round to face him, I lean back and rest the nape of my neck against the piano, he lifts my skirt and penetrates me.

*Je jouais... Nous jouissions.*

I was playing... We were playing... We came together to play.

*Malisa*
*Lausanne, Switzerland*

# JULIE

As the sun was rising, so too did Jules and I begin to stir. He got up first and decided to go and prepare a fruit juice and bring me a cup of milk. A morning like any other. I went to join him to say good morning with a delicious kiss on the neck. The kiss became more and more insistent and I slowly started to go down toward his cock. It was then that he pulled me up, smiled at me, took a small stool and installed it in the corner of the kitchen. He sat me down on it with good humour and sweetly asked me to carry on from the point at which he'd interrupted me.

A blowjob is all well and good, but as certain French-speaking plumbers like to say, a *pipe* is certainly better when it's properly installed!

*Julie*
*Philippeville, Belgium*

# MARION

It was late. We were at a party with friends, and in-between the odd glass or two of wine, we decided we wanted to play hide and seek like children. So off we all ran into the house. Somehow, my boyfriend and I both decided to go and hide in the same spot, behind a curtain. I was wearing pyjama shorts, and he started to slip his hand inside them and proceeded to try to make me cum by playing with my clitoris, while the person looking for us was continually passing back and forth on the other side of the curtain. It was an encounter with excitement, fear and pleasure, and all I needed to take me up to heaven.
Nobody ever found us.

*Marion*
*Pau, France*

# MILÉNA

In a bid to relieve me of my headache, my lover placed his penis on my forehead.
Amused, I told him that the magic wand was now in place, to which he replied, laughing: "*Expecto Penissum!*"

*Miléna*
*Caen, France*

# GALA

Today it is my body, most of all, that yearns for you.
So when the longing is too strong, when desire burns too bright,
my hand slips between my thighs along the path left damp by
memories.
And with my fingertips, I think of you...
I can taste your kisses on my lips.
Between my thighs, the flavours of the past, the sweet caress, the
spice, our sweat entwined.
*'Que reste-t-il de nos amours?'* What is left of our loves?
Waves of solitary pleasures, the index and the middle finger
rekindling memories and making bodies tremble.

*Gala,*
*France*

# RODOLPHE

Light passes through the fogged windows of the cabin.
A sudden grab, and the corset snaps undone.

*Rodolphe and Adélie*
*Paris, France*

# THOMAS

I could write a whole book about this stunning woman that I fell in love with in Ljubljana. We had an extraordinary physical relationship. Sexual tension around the clock, 24/7.

Even on a visit to the museum in Tivoli Park. We both found the exhibition very boring, so all it took was a simple glance and a naughty smile for us to disappear behind the curtains in a store room in the Museum. She unzipped me, wildly, and gave me the most incredible blowjob, as I watched the people walking around in the park through a little window, while stroking her hair.

When it was over, we left, convinced that no one had spotted us. As we were going back out past the ticket office, the guard told us something that only my girlfriend was able to understand (since I don't speak Slovenian). "Any chance of a smoke for me?" which implied, in this context, that he had seen everything we had been doing on the CCTV screens.

In Slovenian, this phrase is an innuendo: when a guy says it to a girl, it's a blatant request for a blowjob.

She just laughed out loud and kissed me on the mouth.

And I was left there, simply rooted to the spot, stunned by her incredible lips.

*Thomas,*
*Ljubljana, Slovenia*

# MATHILDE

My beloved and I were enjoying a day of steamy passion on a barge. We thought we were quite alone in the world... until we saw, through the window, a bunch of people gliding past on their paddle boards, very keen to give us a hearty greeting...

*Mathilde*
*Achères, France*

# HANNAH

My girlfriend and I had just started going out together and we couldn't keep our hands off each other. One afternoon, we started kissing on the sofa, and as things began to get more and more heated, she took off my panties, and before getting her hands between my legs, she lifted me up and sat me down on the windowsill, which was – as we had somehow both forgotten – covered with cacti.

I ended up with a pretty impressive bunch of thorns implanted in my bum, and she had to remove them one by one with tweezers.

*Hannah*
*Manchester, United Kingdom*

# ALICIA

I was quietly enjoying the first rays of sun by the pool, in my new little fancy swimsuit, with a nice wide-brimmed hat on my head and a big pair of sunglasses, sipping away at my fruit juice like a film star. My boyfriend showed up and without saying a single word, he simply started to eat my pussy. I didn't say anything either. I simply pictured myself as a rich and famous woman, being given a little treat by her gardener.

*Alicia*
*Montreuil, France*

# CHLOÉ

An everyday journey. Hands on the wheel, the touch of a simple dress against my skin; it's me doing the driving.

His hand slides across my knee, beneath my dress, and dives between my legs. I clench my thighs. He spreads them a little wider apart. My legs open, and then my eyes close. "The road, keep your eyes on the road." Caressing me. The more he touches me, the less I am there. "Concentrate." He accelerates, I slow down. I watch the road, I feel his fingers. The lights flash past, sounds disappear. My body straightens, my head spins.

Automatic transmission for manual pleasure.

A journey never to be repeated.

*Chloé*
*Lyon, France*

# ÈVE

I was taking dance lessons in a beautiful old building at the time, and I ended up making love with another dancer on the creaking wooden stairs that led up to the dressing room. I remember our tutus strewn abandoned on the ground, the Art Nouveau decor of the venue, and the ballet being staged between our intertwining tongues, a form of dance I found infinitely more pleasing than classical ballet.

*Ève*
*Strasbourg, France*

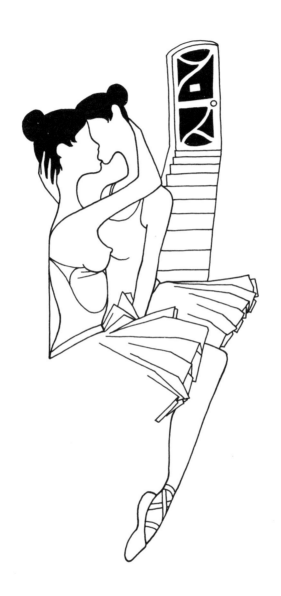

# NOLWENN

One morning, following a night of passion with my lover, I was unable to track down exactly where I'd left my knickers. Already late, I put my skirt on in a hurry and headed to the metro. When I got to the station, a train chose to pass by at the very moment that I was walking over an air vent. The problem was that I had neither Marilyn's reflexes, nor her panties... to the absolute delight of the passers-by.

*Nolwenn*
*Paris, France*

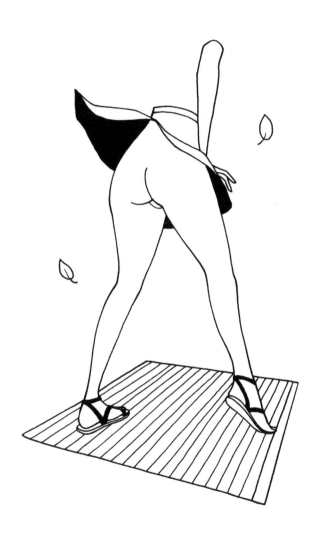

# PETER

Hot and damp from our exertions, we left her room, which was aglow, through the window and down into the moonlit garden. Our sweat mixed with the cool morning dew as our bodies sank back into the softness of the grass, smiling and laughing as we enjoyed each other's lithe forms. We devoured each other, entering first from one angle, then another; two steaming bodies that had long since abandoned the clumsy language of words for the divine language of physical touch.

Her black cat watched us from the roof of the shed, a furry voyeur to our night without end.

*Peter*
*Baton Rouge, United States*

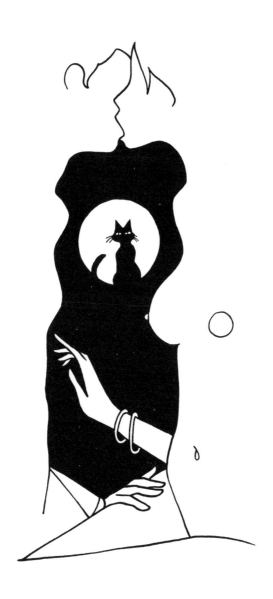

# GABRIELLE

I was on holiday in Mauritius with my ex. One evening we decided to go for a swim, for a naughty little midnight dip. Our business concluded, we noticed some kind of black tube moving about in the water and we got ourselves out of there at whirlwind speed.

It turns out that it was a tourist who liked to go diving at night with his snorkel. And he got to see our hanky-panky in all its glory!

*Gabrielle*
*Bordeaux, France*

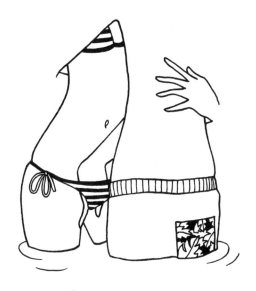

# MANON

It happened one summer, at the top of a hill on the Côte d'Azur, with blue sky, radiant sun and the chirping of the cicadas... A gorgeous view overlooking both the city and the sea, far from the noise, but close to the dream... The two of them entwined, the girl sitting on top of the boy, amidst the rosemary and thyme, hidden in the undergrowth... Laid out on the ground, in the long grass, going doggy-style and missionary atop a military jacket... a petite blonde and a tall *mestizo*, an unforgettable afternoon, far away from prying eyes and from reality.

*Manon*
*Côte d'Azur, France*

# PAULA

He was ten years older than me, and he was giving me a lift back to mine.

I opened the door and in he went, hurrying up the stairs to see if it was possible to go out on to the roof... I followed him up.

We couldn't go outside because the door was locked, but we ended up making love on the top-floor landing of my building, where any one of my neighbours might have seen us, if they'd just happened to open their door.

It was a precious moment, with the moonlight coming in through the skylight, setting off his tattoos with a beautiful, gentle glow...

*Paula*
*Madrid, Spain*

# LOUISE

I got up from the table and turned to cut the cheesecake I had ready for dessert. He came in behind me and bent me over the kitchen worktop. He took the knife from my hands, spread my arms either side and pressed my head down.

"Stay down", he said. He lifted my dress, and I shivered with excitement when I heard the buckle of his belt coming undone. As he thrust inside me, I fell even further forward, and my breasts and elbows landed in the cheese cake.

Once we'd finished, we lay back on the floor, panting, covered in cream and laughing at what had just happened.

*Louise*
*Glasgow, Scotland*

# MAXIMILIEN

We were invited to a costume ball; I was dressed as Louis XV and she as Pompadour. As the champagne went to our heads, I felt possessed by the soul of a king and gently took her on the billiard table that was enthroned in the library.

Despite our burning passion and the ardour that consumed me, I had great difficulty unhooking her bodice. When it finally gave way and her stockings were removed, and all the preliminaries were over, we gave ourselves to each other with such complete abandon that by the time our antics had subsided, all the balls had been dispatched to their pocket. In short, it was a win-win game, this costume ball.

*Maximilien*
*Charleroi, Belgium*

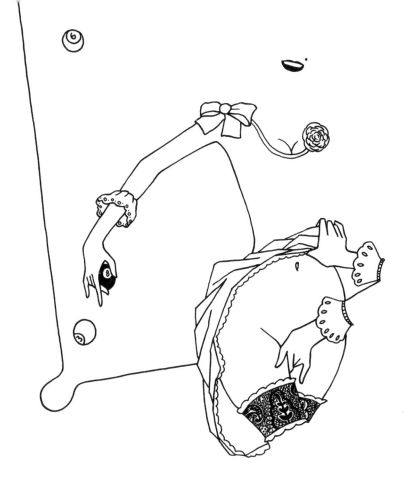

# EMANUELE

One day, I made love for the sake of love.

*Emanuele*
*Italy*

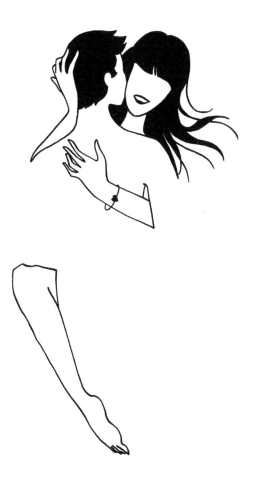

The author would like to thank everyone who has helped him to realise this book, particularly dear, sweet Céline, who has been responsible every day, for so many years now, for pushing the project forward. Without her, Petites Luxures would barely have had a life expectancy of forty-eight hours:

Alexia, Alicia, Athena, Bella, Bianca, Calame, Chiara, Chloé, Chloé, Elena, Emanuele, Emma, Emilie, Eve, François, Gabrielle, Gala, Gigi, Gwen, Hannah, Jessy, Julie, Julien-Brice, Kelly, Lisa, Louise, Lucas, Mahiéddine, Malisa, Malvika, Manon, Marianna, Marianne, Marion, Mary, Mathilde, Maximilien, Miléna, Morgane, Morgane, Nolwenn, Paula, Peter, Rodolphe, Rose, Stan, Tamara, Thomas, Thomas, Victor

... plus the hundreds of others whose stories, alas, could not be included in the current publication.
Never stop loving each other and having fun!

MARKED is an initiative by Lannoo Publishers.
www.markedbylannoo.com

  @markedbylannoo

Or sign up for our MARKED newsletter with news about new and forthcoming
publications on art, interior design, food & travel, photography and fashion as well
as exclusive offers and MARKED events on www.markedbylannoo.com

If you have any questions or comments about the material in this book,
please do not hesitate to contact our editorial team: markedteam@lannoo.com

Graphic Design: Simon Frankart
Translation: Duncan Brown
Typesetting: Keppie & Keppie

Original publisher: © Editions Hoëbeke, Paris, 2019
© English edition: Lannoo Publishers, Tielt, Belgium, 2020
D/2020/45/289 – NUR 455
ISBN: 978 94 014 6895 4

#AREYOUMARKED